It's Spring

by
Jimmy Pickering

smallfellow press
LOS ANGELES

To Bob

Thank you for being the most amazing mentor,
design guru and "wonderful" friend the seasons have sent my way.

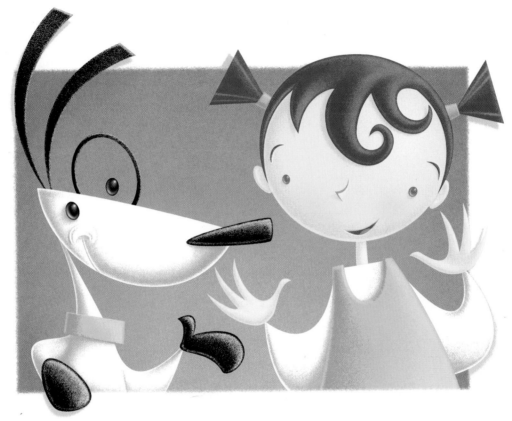

Sally and Sam see that something is strange:
The snow-covered landscape's beginning to change.

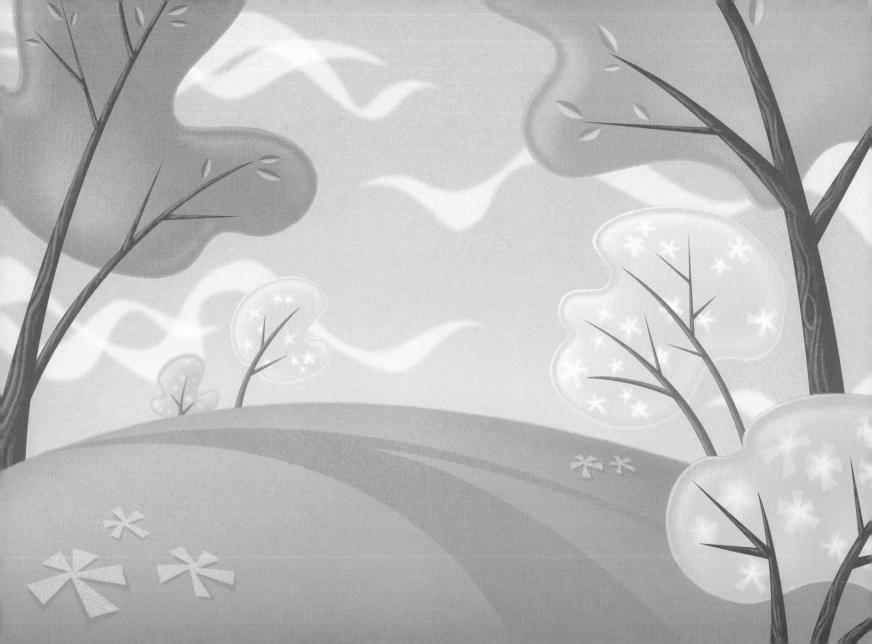

For Spring has arrived
And is waking the trees,

Their tiny young flowers
Attracting the bees.

With Winter just ending,
The two venture out

To truly discover
What Spring is about.

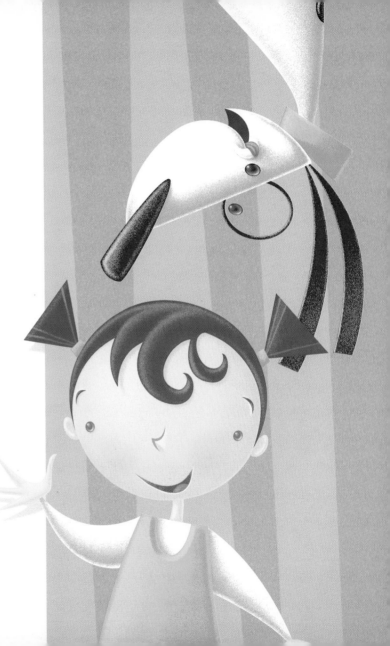

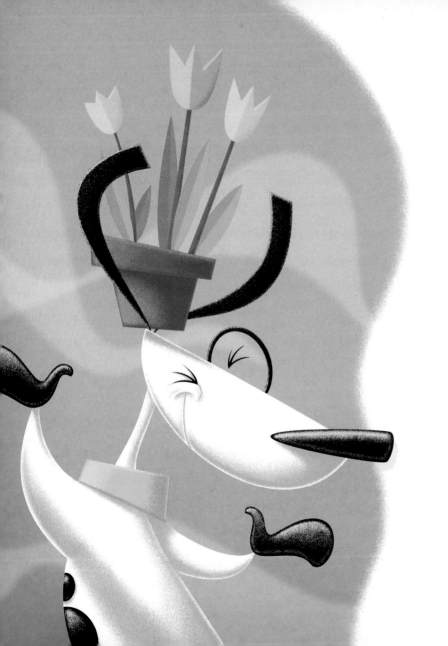

The flowers are blooming
and dancing around;

Tulips and daffodils
Cover the ground.

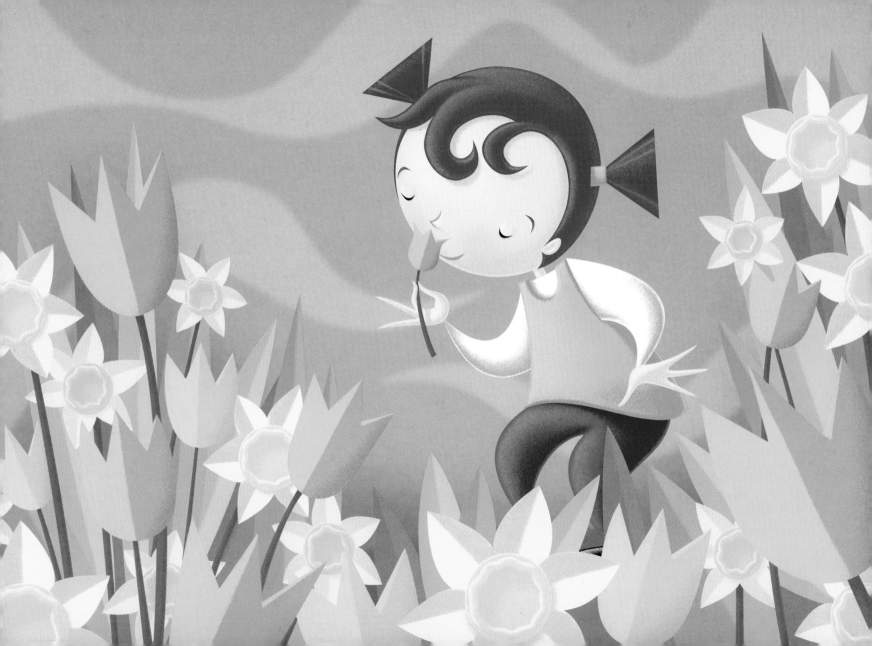

In Spring you may find yourself
Pulling up weeds

And tilling the soil
For the planting of seeds.

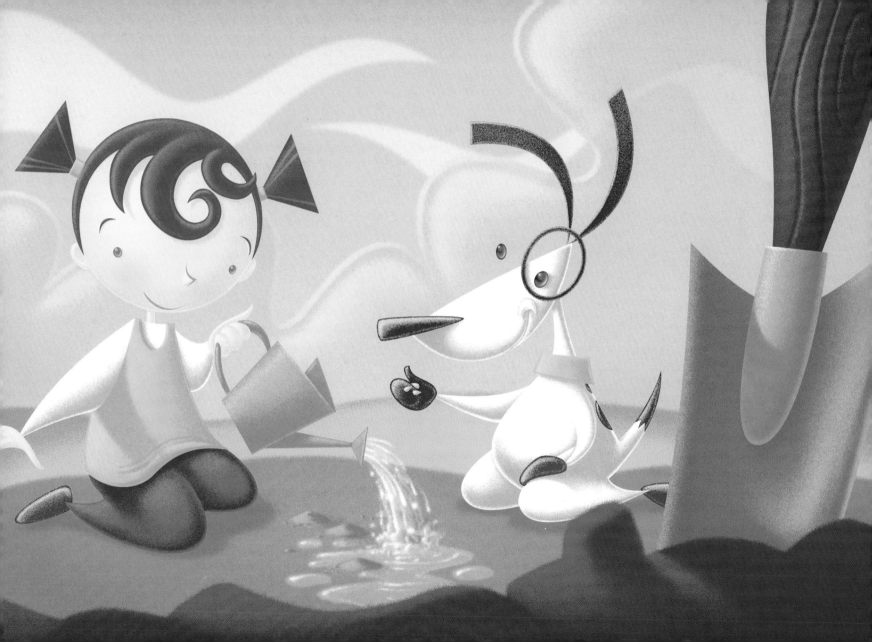

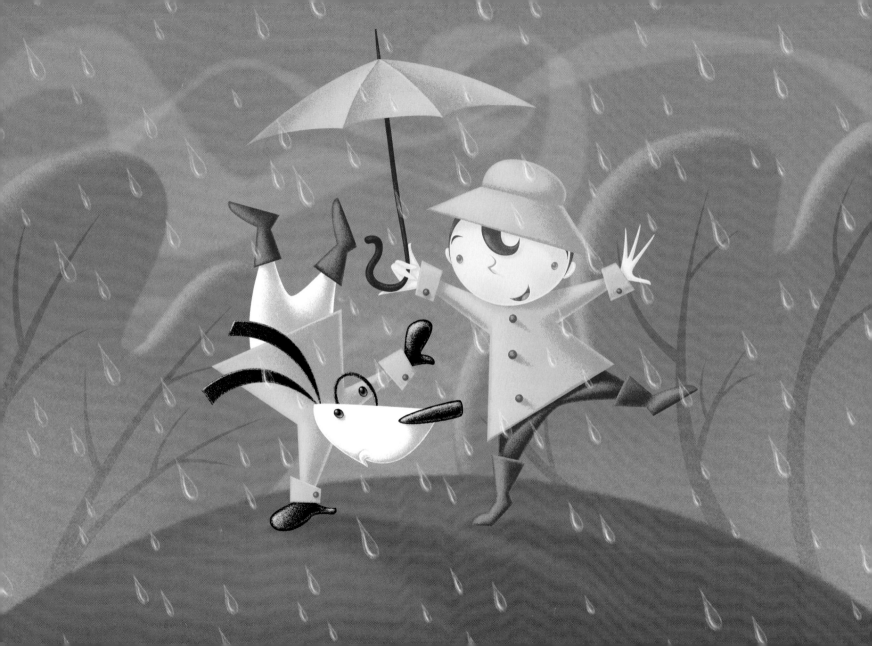

Now some think that rain
Means you must stay indoors,

But Sally and Sam think
It's fun when it pours.

A gorgeous Spring day
Is the time for a treat

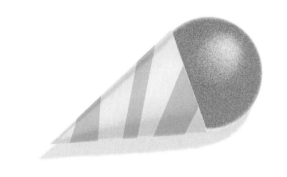

And colorful snow cones
Cannot be beat.

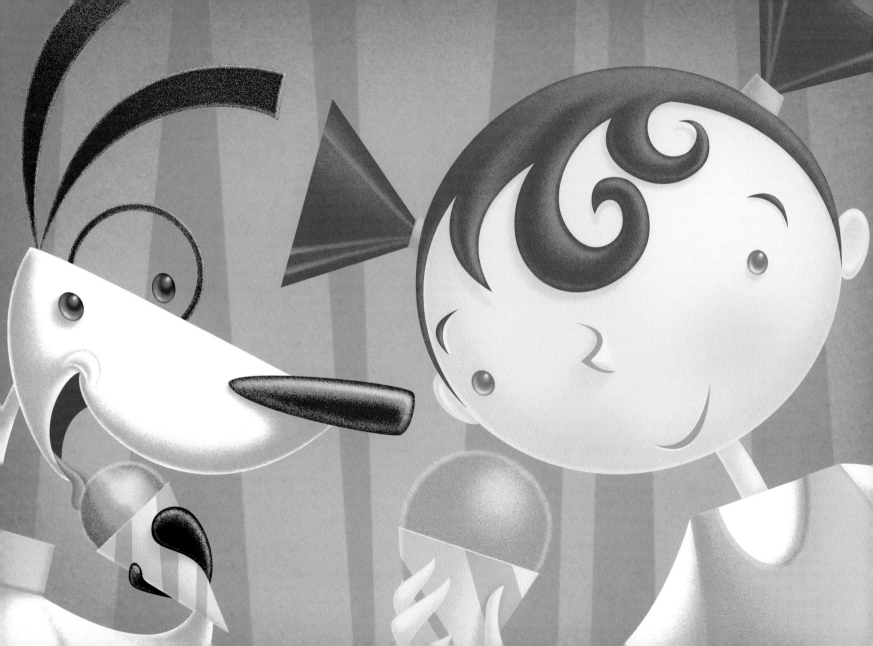

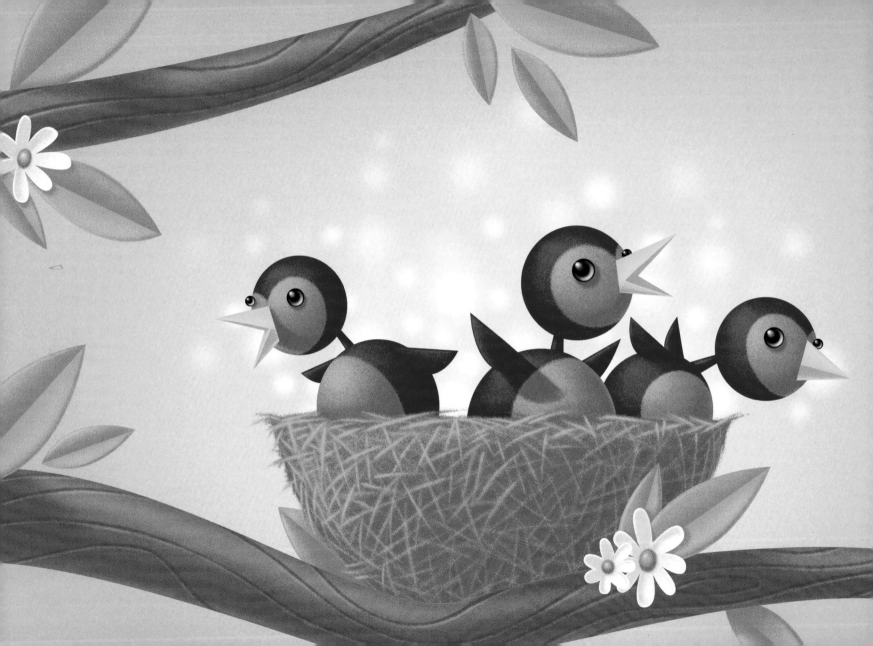

Ooh - Sally and Sam hear
Some noise in a tree;

They find baby
whippoorwills

Chirping with glee.

With carpenter's tools

And some paint by their side,

They build a small house

Where the birds can reside.

They sit close together while gazing up high
As silly cloud figures appear in the sky.

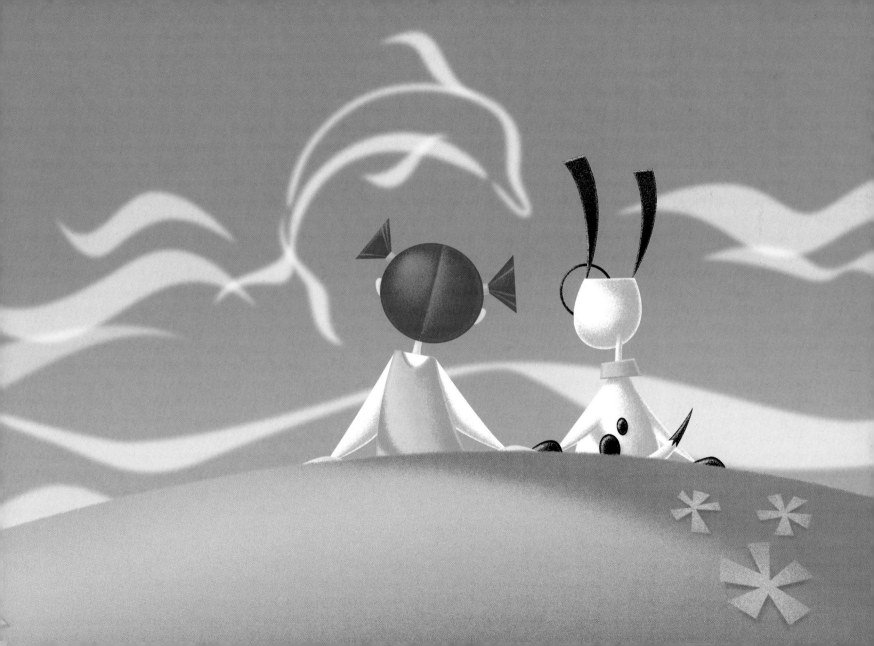

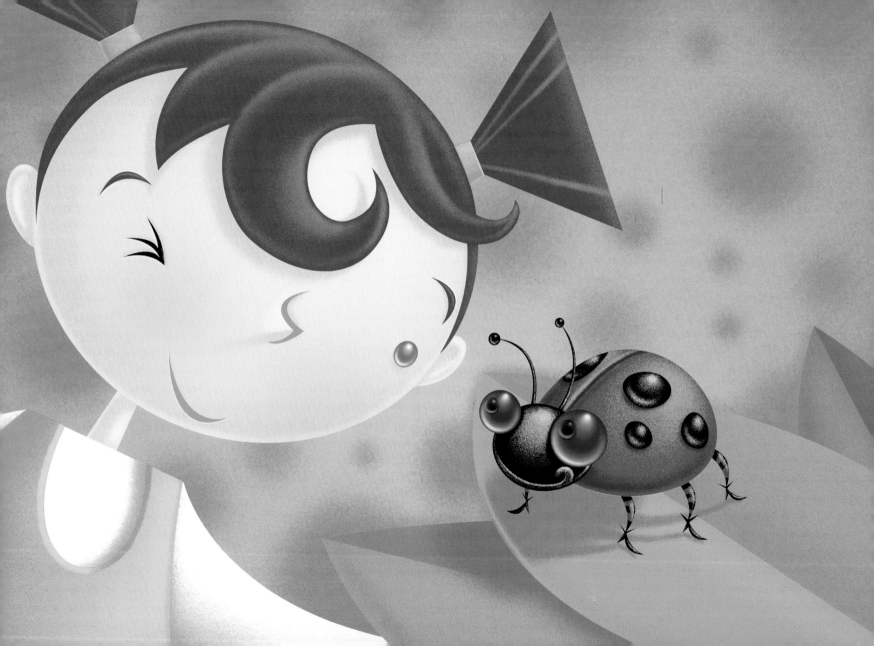

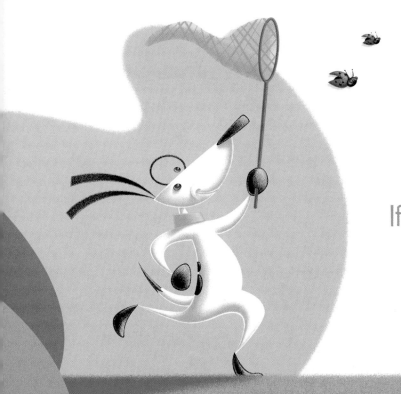

Ladybugs are lucky,
or so Sally's heard.
So she makes a wish without saying a word.

Sam, on the other hand,
wants to play tag.

If he could just catch one,
He surely would brag.

They hunt and they gather
Some daisies today

And make their own jewelry
The old fashioned way.

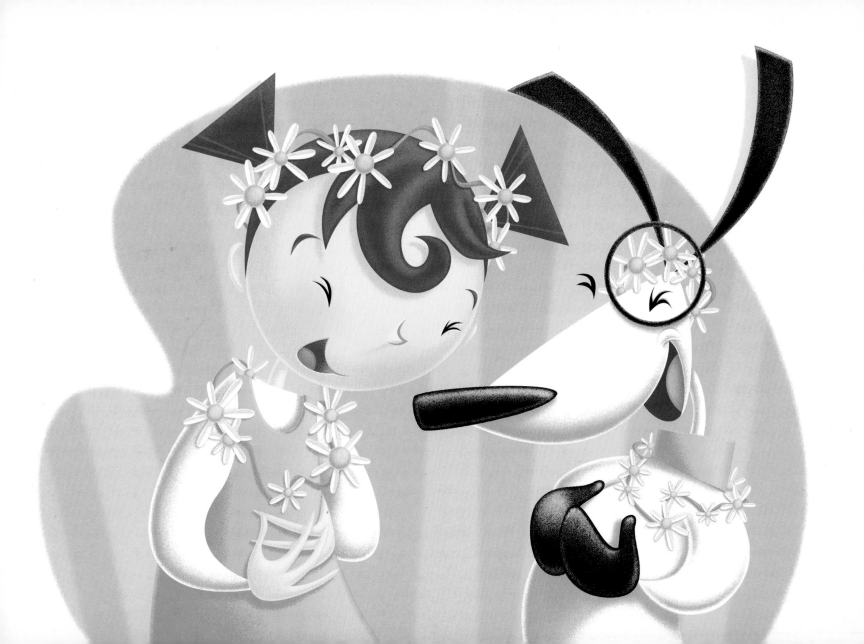

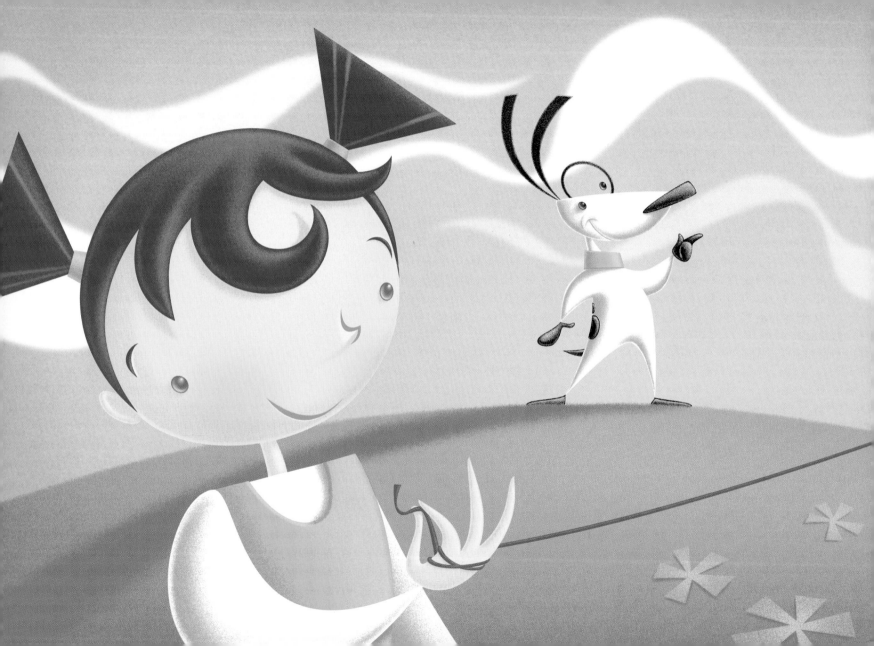

With paper and balsa they fashion a kite

Which takes to the sky

On a magical flight.

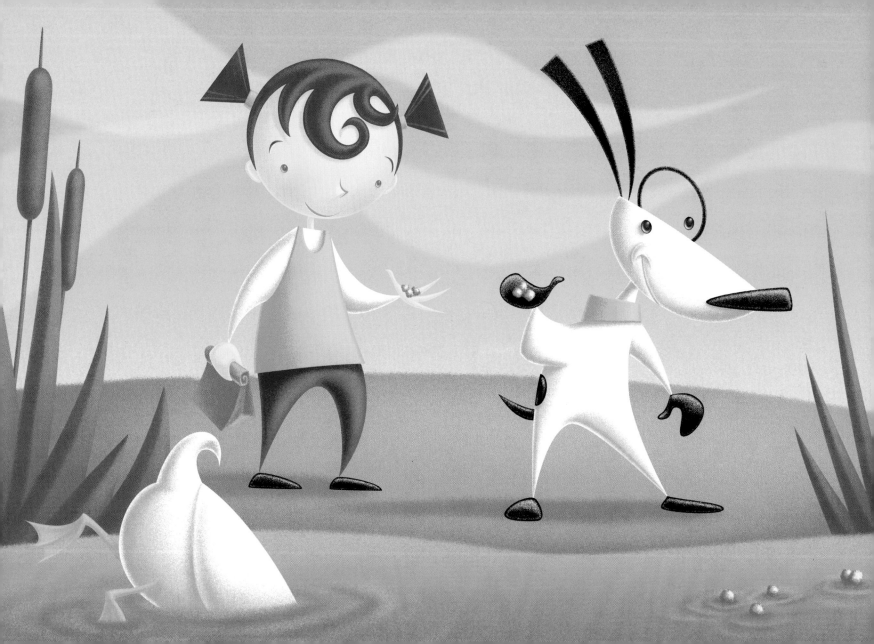

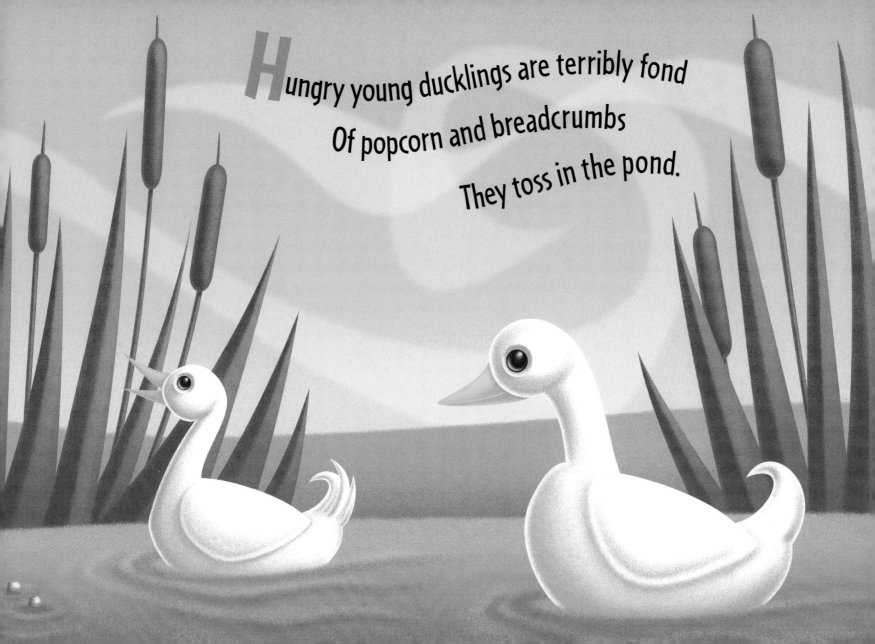

Hungry young ducklings are terribly fond

Of popcorn and breadcrumbs

They toss in the pond.

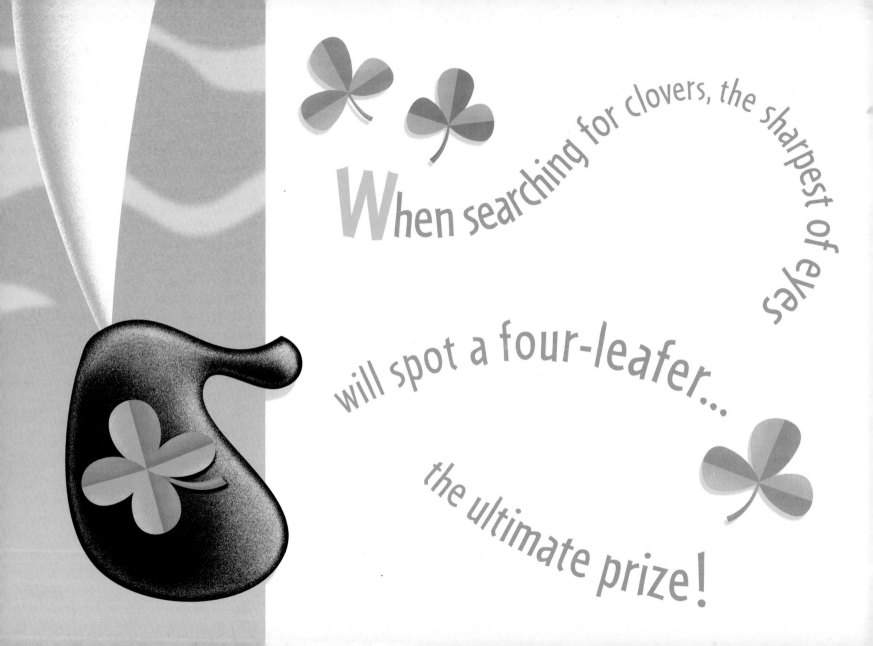

When searching for clovers, the sharpest of eyes will spot a four-leafer... the ultimate prize!

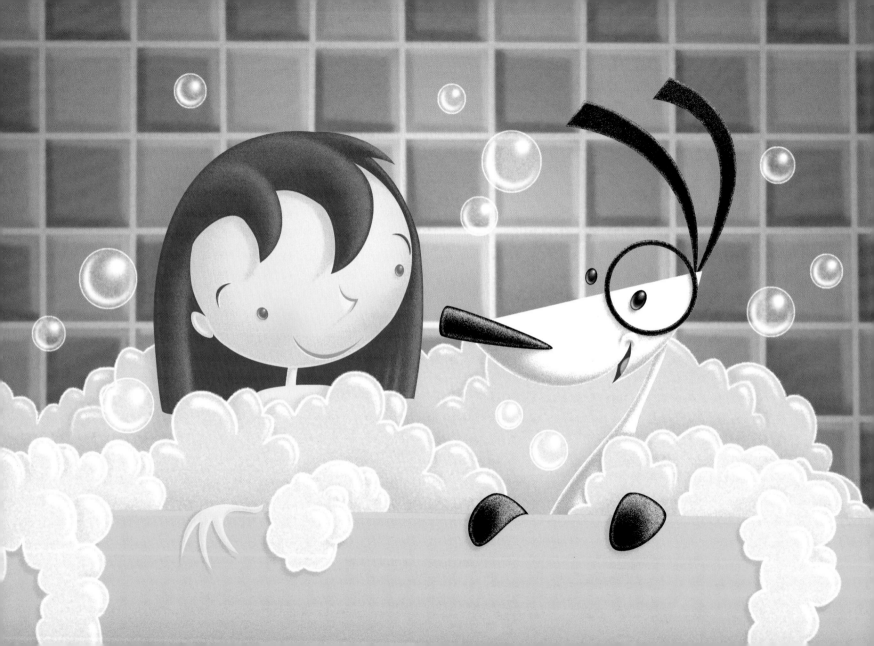

So after this day of discovering Spring,

And seeing what joy a new season can bring,

They think of tomorrow, another new day,

When they will awaken
to SPRING up and play!

Published by
smallfellow press
A division of Tallfellow Press, Inc.
1180 S. Beverly Drive
Los Angeles, CA 90035

Type and Layout: Scott Allen

ISBN 1-931290-22-9

Printed in Italy
10 9 8 7 6 5 4 3 2 1

Tallfellow Press, Inc
Los Angeles